BEIGE PURSUIT

BEIGE PURSUIT

Sara Magenheimer

WENDY'S SUBWAY

TABLE OF CONTENTS

LIKE CLOCKWORK

Cabin sounds: thick beige noise, muted footsteps, clinking of change, utensils, glasses, indistinct voices, etc.

A calm female voice:

> We hope you have endured our friendship in-air.
> We are now preparing to fall.
>
> The bar is closed and we will soon collect your love.
>
> May I remind you to form your soft pink shape by the time we sublimate.
>
> This is your last chance to use words.

Another voice says:

> Prepare for changes.

A calm female voice:

> Ladies and Gentlemen, now we're approaching Soul where the local time is always.
>
> At this stage you should be secure in your body with your clothing cool and loose.
>
> Personal visualization hats
> miniature forests
> and retractable comfort architecture
> must be concealed

and all distractions stored
either in the overhead abyss
or in the small hole in front of you.

Please ensure all pleasure devices including laptop
computers are *shhhhhhhhhhhhhhhhhhh*.

You are in the Elite class section.

You will sense control everywhere you look.
You will sense submission everywhere you look.
They are the same.
The call button and entertainment system are on the
inside of your palm.

In the economy pit, these controls are located above
your shaved skull.

To adjust your cage, push the round bottom and
notice it is false.

It falls.

Fancy tea, coffee, and full bar service will be avail-
able if you can swallow what I say.

If you require any special assistance, please caress the
care creature nearest you.

We are here to ensure that you have a comfortable
and enjoyable rebirth.

Later on, we'll dim the cabin lights so you can imagine a better way.

We recommend that while asleep, you keep your heart open.

This way it will not be necessary to wake you should you become terrified.

If you don't want to be seen eating breakfast, please perform a newborn disguise:
Close your eyes.

Natural reality and abstract reality say their goodbyes.

Guests are welcome.

We are joyful except when we think, i.e. "Our ego is not our amigo."

Your body is a naked battlefield
This trip has exfoliated language from its skin
Cut down brush
Slash and burn

This trip has turned words illegal
The linguistic infection has been cured
There are no more immigration forms
So-called urgent emails and
Overdue paperwork have been exorcised like the
demons they are
No documents
No body is legal and no body is illegal
No fear of birth
No fear of death
Only love

Like clockwork

Like clockwork

Like clockwork

Like clockwork

Like clockwork

Like clockwork

Like clockwork

Ticking, syncopated sounds start soft and build, then crossfade with the sound of muzak.

Interior: a waiting room

DOCTOR: Thank you for waiting.

PATIENT: Hi doctor, it's no problem.

They walk to the exam room.

DOCTOR: Well, what seems to be the problem?

PATIENT: So, I've been waking up at 5am to the sound of a million bottles breaking in the street. It's the recycling program and it takes four hours. The right side of my neck never seems to shift into the right place, so it feels stiff, painful, and like it needs adjusting all the time. There's a metaphorical knife literally stuck in my lower back. My right nostril is stuffy. My knuckles and joints crack too much. I pick at my cuticles. When I dream I'm flying, my heart rate speeds up rapidly until I wake up in a cold sweat. When I dream I'm swimming, I hold my breath for too long and I wake up gasping for air. I have constant stomachaches. My eyes water and my nose runs. I have a twitch and a tick. I fidget.

DOCTOR: I think we all understand these symptoms. It sounds like you have the condition of being human.

PATIENT: Is there any cure?

DOCTOR: Be patient.

PATIENT: Be doctor.

DOCTOR: I am.

PATIENT: I am.

DOCTOR: I am.

PATIENT: I am.

DOCTOR: I am.

PATIENT: I am.

DOCTOR: I am.

PATIENT: I am.

DOCTOR: I am.

PATIENT: I am.

DOCTOR: I am.

PATIENT: I am.

I am

I am

I am

I am

I am

I am

I am

I am

I am

I am

I am

I am

I am

I am

I am

I am

I am

Diseases ARE.

We do not make or unmake them at will.

We are not their masters.
They make us, they form us.

They may even have created us.
They belong to this state of activity which we call
LIFE.

They may be its main activity.
They are one of the many manifestations
of universal matter.
They may be the main
manifestation
of that matter
which we will never be able to study

except through

relationships
and analogies.

Diseases are a transitory, intermediary, future state of
health.

It may be that diseases are health itself.

Coming to a diagnosis is, in a way, casting a physiologi-
cal horoscope.

What convention calls HEALTH is, after all,
no more than this or that passing aspect of a morbid
condition,
frozen into an abstraction,

a special case

already experienced,
recognized,
defined,
finite,
extracted,
and
generalized

into
LANGUAGE
for everybody's use.

A disease is a word
we travel inside
a leaky boat
that carries us
from shore to shore.

BEIGE PURSUIT

X pursues Beige nuance, seeking the last perceptible trace of something on the cusp of no longer existing, yet still, it exists. She reaches for her life as she knows it even as it slips out of her grasp. She is already in a threshold state: she is no longer where she was, yet hasn't arrived where she's going. On her way to a new name she still answers to the old one, but it seems a little hollow now, more like a childhood nickname.

X is being pursued by Beige, by a substanceless cloud of nuance without context. The algorithmic average of preferences and affinities. The sharp shape that has been sanded down to resemble a donut hole. Safe, yet ultimately unsatisfying, with no edges or corners.

There is a vacillation, a simultaneous attraction and repulsion between poles. A pulse beats through a beige veil, a scrim on the world, a membrane.

Sounds and scents at the edge of the woods:

Things were beginning to feel too familiar. X, wishing to be absorbed and lost, entered the dense green woods following a sound.

16 seconds of warm pink noise. An inhale: Grace Slick's isolated vocals from "White Rabbit" begin, full of warm ribbon reverb, as if she were recorded in a large room. Her calm confidence inflates each word and, one by one they take off, helium balloons lifting the song higher and higher. The balloons take over, she becomes a passenger carried by the song's velocity, her voice rides straight to the top and explodes FEED YOUR HEAAAAAAAD FEED YOUR HEAAAAAAAAAAAD. As Grace Slick's voice fades we hear the sound of a clock ticking.

X says out loud, "The world is so fucking weird. I am in the world so I'm weird, too. Let's see how bizarre the world can get and how far I can go from home."

Strangeness and distance are important. Memories live in the discovery of the familiar, the known, within the new. The surprising recognition—the glimpse of one's native language peering out of a foreign text.

X fondles an unremarkable leaf in a hedge carved into a maze. She takes a picture of it, knowing she'll need to return to images later to find her way back.

X enters the maze, remembering as she walks:
One day when X was about three, her parents got in a fight.

They screamed at each other, louder and louder, over "We Are the Champions," which was playing on Q102.

Her mother threw a jar of maraschino cherries at her dad, and missed.

Splattered all against the wall.

X took one look at the cherries and decided to become an artist.

In a corner of the tall hedge maze, X finds herself facing a ladder. X climbs the ladder. Seems like it takes forever.

Climbing, X thinks, "The only way out is up."

In the forest, X finds a book on a rock:

"Choose your own adventure." Takes it literally.

In the middle of the forest, X meets a talking mushroom declaring platitudes to a rapt bed of pansies while exhaling smoke in the shape of letters that grow in size as they ascend, fading up into clouds. Records video.

MUSHROOM:

To understand is always an ascending movement.

Hope that is seen is no hope at all.

You pick the enemy you become.

X decides she neither wants to go up nor down, but IN:

X knocks on the Letter Carrier's door not with her fists, but with words, "Open! Knock Knock! Let me in!"

X introduces herself. "Have you read me?" she asks.

The Letter Carrier peers suspiciously out of the mail slot in his front door. "I see the living body of a human woman, not a book," he says.

X is aware that her adventure is situated not merely in a text or in a series of events, but in their coincidence.

The Letter Carrier appears out of nowhere.

X is not the power that preexists the story and makes the Letter Carrier speak; X is the story.

X is not the one who inspires the Letter Carrier to speak; X is speech.

Mushroom's smoke letters float by and X hears her voice in the distance:

To understand is always an ascending movement.

Hope that is seen is no hope at all.

You pick the enemy you become.

X adjusts her voicemail greeting:

> If you need me I'll be in airplane mode
> I'm sorry I'm just seeing this now
> Please leave your message in the sky
> I'll be checking it frequently
> If this year was about looking down
> I'll only be looking up from now on

X follows a vague hum as it grows louder:

She opens the door. She is in a medium-sized fluorescently lit room with perpetually out-of-date periodicals where everyone waits to assimilate into the same story.

X watches:

People milling around impatiently, busying themselves on their phones, picking at their cuticles, turning sticky wrinkled pages of *US Weekly* and *SELF* while gazing out the window at smoke vowels.

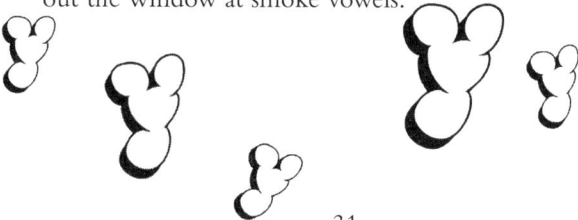

X tastes the atmosphere:

"Oh no!" she thinks to herself. "I'm stuck in a room full of 'powerful, influential people!' They hate waiting more than anything! It's their kryptonite!"

X tries to speak, but her language has been corrupted
by a virus:

Io sonno...(*cough*) hana tool set net
Tahsuht
Yehsut
Eeee
Errr San Shhhh
Otra vez
Pero
Espérame
Mine lieblingsbuch

X overhears, "My cousin Claire wanted horseback riding lessons, but also really needed speech therapy. Since she refused to go to her sessions her mother set it up so that she received speech therapy while on horseback."

The hedge maze turns into tall rows of brightly colored products on the endless shelves at Walmart.

Sounds and voices come to X:

"You cannot commit a crime if you have no name," says a Johnny Cash–type voice.

An unrecognizable song slowed down to the point of abstraction, dovetailed and braided with itself so that the waveforms undulate among themselves. Where one rhythm seems to end it begins again and yet is not a discernible loop. The result is a feeling of lulling calm that never quite settles but remains restless, like a boat moving along the surface of an ocean. There's an impression of a contextless female voice detached from any body.

"The death you die is not a death," says a low female voice.

A radio in a doctor's office waiting room playing "Hurt" by Nine Inch Nails. Outside, birds are chirping. Planes fly overhead. People park cars, get in and out, drive away, etc. Beep beep of remote door opening and locking. The dull thud of doors and trunks closing. Ignitions start, the crunch of wheels driving slowly over already flattened plastic water bottles.

"If you have no name you cannot die," says a shrill voice.

A Chase Bank automated teller machine beeps too often, like it might be stuck or someone forgot their card inside. Muffled voices. An odd chuckle. Indiscernible language. Shuffling of clothes, papers. Sounds like there's a tall ceiling and glass windows. Periodically a door opens and street traffic is audible. Footsteps approach and recede.

X pauses:

With these words.

I hold this space.

I hold this time.

Mine.

X gets a tattoo:

X

X can't remember her old name:

She can only remember that she traded it for something
while waiting at a bus stop.

X walks, looking down:

Sees X on the pavement.

Looks up:

So this is a "Bus Stop."

X waits for the bus:

A big double-decker pulls up; Mushroom opens the door. "Coming?"

X sits in the front seat:

Mushroom offers her some cookies. X says, "Just one," but by the time they reach the next stop the bag is empty and X is a fourth of her normal size.

X turns to Mushroom:

> x: The thing about history is that so much happened, you know?
> MUSH: Everything.
> x: And I wasn't even there for most of it!
> UNISON: SO HOW DO WE KNOW WHAT REALLY HAPPENED?!

X rides the rest of the way on the top of the bus like a hood ornament, arms outstretched, the air firmly licking the surface of her rippling skin.

X surveys the landscape:

An architecture of hopelessness. Structures planning their own demise, fantasizing about collapse, envisioning the crushing sounds, the thick, weightless plumes of dust masking their exhausted return home to the matter from which they came. This architecture houses a fantasy of a fantasy of cause and effect. Play along inside my temporary walls! Check out your costume! We're acting normal! Here's a proscenium of mundane design decisions only visible to the naked eye when it fails to perform, when it falls.

The fall is inevitable. In fact, if you look closely you can see that even during construction the molecules and composite fibers inside the building blocks are starting to rot. The spirit is giving up. Why bother, in the current economy of planned obsolescence, to continue bearing weight? Why should a brick carry on being a brick when the precarious laborers in charge of laying them might be deported tomorrow? Even the mortar spreads more slowly. And you think as a human you are immune?

X's memory in 6-second videos:

Words describe things she couldn't photograph (black)

Or

Things that the baby recorded (blur)

Or

A hand touching something at Walmart (grey)

Or

Video taken underwater by accident (blue)

Or

Pocket video (lint)

Or

Extreme close ups of a palm (pink)

X has a distant feeling that she might actually be strong, though she's never felt weaker in her life. She looks at the X tattooed next to a mole on her arm. If she reads the mole, it spells "XO." *So I'm someone who gets tattoos now? Is this supposed to remind me of the strength I once had?*

X sees a frayed rope lying on the sidewalk and remembers a friend:

Z was known for introducing rope sandals to the New York fashion world and consequently the general public. This girl could make anything look good. She was tall and thin and looked vaguely like Cher, but with short hair. She was born in Virginia and called everybody "Darlin'." It was like Cher calling you "Darlin'." The affection felt great. X bought a pair of rope sandals, too. They'd take walks around the neighborhood in the sweltering summer, squashing around the block in their stinky, absorbent rope sandals. People used to tell her they wanted her to be their "muse," which she found offensive. She was great at math. Her talent at making patterns and getting the right fit propelled her up the ranks at Donna Karan. But then she quit, moved out west to East LA, started her own clothing line—workwear jumpsuits—and a band with her husband. They had a son named Rumor. Anyway, that's who taught X how to smoke weed.

X searches:

For something, but doesn't know what. Is it a thing, a person, or maybe the end to that incessant sound? Maybe if she finds its source it won't bother her so much.

X finds a pair of wireless headphones on the ground on which is written a note:

"Listen to your inner voice."

X puts on the headphones and hears a female voice singing "Love Me" by Bo Diddley over and over again.

You know
Know that I love you
Oh I really care
Baby Sugar
Honey Darlin
You know that I need you
I want you
By my side

Oooo ooooooo
Oooo Oooooo
Oooo

Some people say
That love is so strange
I wonder why
That they
Take it for a game

Ohhhhh oh oh ohoh
Ohhhhh oh oh ohoh

X sees something shiny on the ground, digs around, unearths Disney's Epcot "Nations of the World" wristwatch. "Finally, I'll know what time it is!" she thinks.

She picks it up and fastens the shiny little buckle. Trying to read the face, she squints. Is that noon? Something is wrong. A tiny ant has grasped the hour hand and dangles off towards the 1. How can she trust this inhabited device? The 2 and 6 start moving as more ants rapidly appear, climbing out through the numbers, hunting around the face. She shakes it off her wrist and throws it in a puddle where it lands face up, ants continuing to emerge in reflections of passing clouds.

X opens her weather app:

Checks the weather in Beijing, Rome, Riga, Anchorage, Los Angeles, Paris, Tokyo, and Jakarta.

X makes a video:

It starts twenty minutes in and ends fifty minutes before the end.

X decides she needs to move:

Packs everything up in boxes. Calls Sisterly Movers and big women come to gently shepherd her belongings into their truck.

X stumbles on a log while walking in the forest:

It makes a musical sound. She realizes it IS an instrument! Someone has hollowed it out like a tongue drum so that parts of the wood play different notes. She holds her bag of groceries upside down and fruits and vegetables pour out, making gorgeous music as they land. She collects them. One by one her fingers press into their bruises, the score imprinted on their soft flesh.

X hums along with a vague drone as she goes up an escalator in a shopping mall:

If Music is Muzak, then Art is Ort, Painting is Peintang, Sculpture is Skullptore, Architecture is Architakture, and so on.

X hears Mushroom's voice over the loudspeaker in the mall's food court. People pause mid-chew to listen obediently.

Attention shoppers:

A person's color is the color of the wind prevailing at the time of their birth.
We're witnessing a conversation between a woman and her soul named X in the shape of a large city.
Talk of a foreign place called America where people often get shot.
Molecular interchange between people and objects with which they spend a lot of time (phones).

Shoppers resume chewing.

An older version of X walks backwards into her, but doesn't turn around.

X emerges from the mall, blinking into the bright out-door light of the parking lot:

A car exactly like X's is parked behind X's, and she tries unsuccessfully to get in the driver's seat. A barking dog shocks her into realizing that the car doesn't belong to her.

Months later X says to her friend, "I think that's my doppelgänger," pointing at the person who walked backwards.

FRIEND: No, it's not.
x: I was wrong. I was wrong.

X prints out orange stickers that say PAID in black.

X goes to the museum, accidentally rubs against an ancient vase and out comes a genie:

GENIE: I will grant you one wish.

X: I wish for two wishes.

GENIE: Your wish is granted. You get one more wish.

X: OK, I wish for three wishes.

GENIE: Your wish is granted. Two more wishes.

X: I wish to never have to fill out paperwork ever again.

GENIE: Are you allergic to bureaucracy?

X: I used to think so, but now I wonder if I even understand its nature!?

GENIE: Bureaucracy must begin in the body, where everything starts.

X: Is it in the arteries and capillaries that carry blood from the heart? Are varicose veins the out-of-date paperwork of the body, only serving to remind us that everything within still matters, however functionless, yet we are not defined by any single one of those corporeal parts, and there is room inside us for extra, useless things (like art) as long as they aren't too big?

GENIE: You have one more wish.

X: I wish for a socratic voice assistant who only asks questions.

GENIE: Your wishes are granted. You will call her "Mom."

X: Mom, can everyone on earth please have their own tag that clearly describes why they are the way they are, the way potted flowers have their names

and how to care for them printed on a piece of plastic and stuck in their pot?

MOM: Why do you search for answers where there are none?

X: Mom!

MOM: Would you like to meet the oldest pasta-making Nonna in the world?

X: Will her recipes transport me through space and time, connecting me with generations of my Italian ancestors? Will she have answers?

MOM: Is a recipe proto-blockchain?

X: It depends on which book you read.

MOM: Is the recipe book a wall?

X: Why are you licking the wall?

MOM: It is full of salt. I crave that mineral!

X: I always thought your cooking was too salty!

MOM: Is there anything else you want to ask me?

Why does my toe itch?

How do I stop picking at my cuticles?

What's the best way to navigate between your needs and the needs of a group?

What's my rising sign?

How do I get wilder but still feel safe?

What do I do if I'm standing outside and I'm bored?

Who is my biological father?

What is the fastest animal in the world?

How many people unconsciously treat me like their mom?

Do I treat myself like I treat my mom?

What do you call a Spanish helicopter?

When is a good time to worry? Now?

Is mistranslation the funniest kind of humor?

Do airplanes "live" in the clouds?

What language am I translating into and out of?

Is it a secret if you forget it?

What is the best way to talk to an ignorant fuck?

What's the quickest way to neutralize fascists?

Is it possible to remind someone how love feels?

If punk is mainstream can it still be punk?

Are punks just jerks these days?

Do objects each have their own unique rhythm?

What is my computer's intention?

Can a mirror be haunted?

What is my family's main problem? Inherited trauma?
Undiagnosed mental illness? Poverty?

Are my friends my family?

Why do birthdays stop being good?

Are there puns in heaven?

Why are the dots on potatoes called "eyes"?

Where is the closest sushi?

Will someone make me paella ever?

Is all American food a bad version of other kinds of food?

Does my phone have a soul? Does my phone have an ego?

Is my phone my friend?

Is my phone a narcissist? Is it making me a narcissist or just showing me that I already was one?

Why do babies like mirrors so much?

What emotions do I feel as I reach my hand towards my phone?

Does my phone connect me with my desires or a hologram of the desired object?

What did my childhood smell like?

Where is the nicest town?

Am I on the cusp of greater self-acceptance or just getting lazy?

Why do I have to do it?

What are realistic expectations to have of a phone?

How many times a day should I check my email?

What was the color of Wednesday, July 30, 2018?

Who is going to come through my front door tonight?

Does my voice sound better screaming or whispering?

Am I open to beauty?

How is dew made?

At what age will people stop thinking I sound like a child over the phone?

If I pile up everything I've ever said and done would it create a mountain or a black hole?

Who cares?

Will the car break again today?

How do I understand what I'm trying to understand?

How do we deal with the invisible objects we inherit? (Do I believe in original sin?)

Is there pain in my DNA?

Which question is the biggest?

Where should I look?

Where are my eyes?

Can one perceive one's own form by looking at the surrounding space?

Do selfish people feel bigger?

Could I be interested in anything interesting or only certain interesting things?

What is "content"?

Will prices just keep escalating forever until a single toothpick costs $50?

Can we ever comprehend the complexities of how "context" changes meaning?

Is the response "it's contextual" for wimps?

If I see things from many angles am I a relativist or just open-minded?

What is the color of the sound of my name?

What sort of animal would it be best to imagine myself as while I give birth?

Is there growth without suffering?

Do my attempts to avoid suffering only result in more suffering?

Is that my baby moving inside me or just gas?

What is the closest color to white that isn't white?

What is the best kind of music?

Why do I make inappropriate jokes when I'm uncomfortable?

Should I not have laughed when that small child fell backward over a circle of rocks yesterday?

Do we all cry in the same language?

Do dogs bark in the same language?

Do dogs understand each other or do they need other dogs to translate sometimes?

How long would it take me to become fluent in Mandarin?

What time of year can you get the best blood oranges in New York City?

Is there a bee in here?

What's the best way to get a bee out of a room?

What was that movie Pat told me about the other day?

In which decade should I have been born?

Will my baby have a good sense of rhythm if I keep practicing the drums while pregnant?

If I practice out of time or mess up a lot will he have a bad sense of rhythm?

What was Hitler's parents' parenting style?

Where are the tastiest coconuts grown?

Which font is the most anti-patriarchy?

How am I doing by general human standards?

Why do people keep pets?

What shape is the most non-threatening? Boob?

Would a weapon made from that shape be terrifying?

What makes some words fancier than others? Is it their French origin?

Why are some textures so scary?

What is the ideal bath water temperature?

What would it be like if the president had to be naked all the time and beg on the street for food, which he would only get if he did a good job?

Can the right song make everyone calm down?

Why do people draw their initials in wet cement?

Do I have a sweet tooth or sweet teeth?

Is my computer's keyboard haunted?

Is death the final test in a human's understanding of object permanence?

X asked:

Rational questions about irrational actions
Men making decisions
Men shaking heads shaking hands.

X named:

Her son Noon after the softest time of day
The doughy middle
Men start soft.

X tries to open an old, brown wooden door:

When she reaches for the knob her fingers crumple
against a hard surface. No! A convincing *trompe l'oeil*
has shattered her expectations. The door, on which was
painted a smaller door, opens and we see Mushroom
standing on the other side with an idiotic grin.

Smoke

HA!

drifts up and away.

X looks at herself in the bathroom mirror:

But when she turns around, her reflection stays put and stares blankly at her back. Behind X's reflection is a mirror and in that mirror another reflection stares at the reflection's back. Sensing their gazes, X quickly spins around and so do the reflections. X stares at their backs and becomes concerned that maybe she is actually their reflection and that there is really no way of knowing who is who.

X's memory is fucked:

She stays calm. Decides to change her rhythm instead of panicking. Become syllabic. Punctuate. Fluctuate. Undulate.

X XX X XX X XX X XX

Seen from above: plastered to the sidewalk, a wet news page from *The Brooklyn Paper* with headline "Schneps Media Salutes Power Women." Headshots of two female honorees sit to the right of the article. One looks like it was taken by a professional, the other seems to have had others cropped out of it. Directly below is an ad of equal size for surgery-free back pain treatment with a similar headshot of a "business woman" next to a picture of a medical device, the DRX9000™. Print from the opposite side seeps through. One woman's face has the word "Culture" running backwards through

her mouth. In a small thumbnail listing "Our 2019 Honorees," the word OIL, backwards.

XXX XX XXX XX XXX XX XXX XX

A gentle dusting of snow veils the surface of a white sedan. Tiny orange rust freckles the driver's side door. Tied to the side view mirror is a sap green ribbon with a little brass bell on the end. The gray swish marks across the car's surface trace the bell's swinging and ringing, like it's hung there for years, digging in a grin.

XxXxXx XX XxXxXx XX

The window of a chiropractor's office in which is hung a poster demanding "LOOK AT YOUR POSTURE... OTHERS DO." Black silhouettes are lined up sideways to show their white spines: Correct Posture, Hollow Back, Flat Pelvis, Slumping Posture, Military Posture, Round shoulders. And from the back: Correct, High Right Shoulder, High Left Hip, High Left Shoulder, Severe Scoliosis.

xxxxXxx xxxxXxx xxxxXxx xxxxXxx

The faded rust colored edge of a big beige book, splayed open on the dirty sidewalk, hints at a cover. The pages have been waterlogged and then dried in a wavy coiffure, the hair of an old woman with a lot of time and money, or a Sfogliatelle, the Italian pastry with 1,000 sheets of thin dough resembling stacked leaves.

XxXXxX XxXXxX XxXXxX XxXXxX

In an empty corner of the Fairway supermarket, flanked
by dried fruit and nuts in bulk packages and next to
a round display tree holding bags of more dried fruit
branded "Crispy Fruit," a seemingly abandoned flower
stall. The exterior is painted bright chroma-key green
with a white archway opening into a green interior.
It is entirely devoid of flowers except an odd bouquet
wilting in the corner of a wall-mounted shelf consisting
mostly of greenery and a few red roses. Two rolls of
brown wrapping paper with an illustration of flowers
on them sit on the counter along with a stack of four
woven baskets, a telephone, and an empty royal blue
plastic crate turned on its side. The interior of the small
space is lit from above, which makes it glow a little, like
a stage on which something is either about to happen
or has just happened.

For phrases at a time X becomes:

Frames
Screens
Doorways
Mirrors
Parking lots
Airports
Waiting rooms
Ladders
Bathrooms
Bus stops
Shopping malls
It all depends on how her cells organize
Into which rhythm she makes with herself
What her bossy body dictates

A gust of wind blows a calendar and its open page sucks itself around X's leg like an octopus:

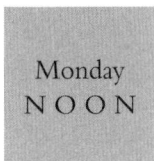

Monday
N O O N

X closes her eyes and walks, bumping into things, enjoying blind sensation and the fear of falling. Little hairs on her arms stand erect, waving hello and good-bye. Constant arrival, eternal departure.

On the street, X gets catcalled by a guy standing in a hole with only his head coming out, "Oh my, oh my, oh MAN! I got to quit my job! I just found my dream girl! SHIT! I can't quit my job 'cause how would I support her?"

He laughs to himself loudly looking down.

X walks away, disinterested in this power dynamic:

Some say a hole is a hole, but this is not a hole it's a whole. Relationship. To sex, to power, to architecture, to control.

Spacing out on the next block, X falls down an open manhole:

Arrives in 1980s America. She can tell by interior decor choices popularized during the Reagan era.

As X falls she says to herself:

My problem is that I forgot my name, and what's worse is that I'm forgetting that I've forgotten it. I'm taking in each moment as it is. It's easy to be egoless when you have everything. The burden of keeping my ego tethered to my soul is all mine. Taking myself seriously is exhausting, but if I stop will I just float away?

X shoots a video:

A young girl touches a child-sized mannequin's face so tenderly, as if she's touching her own reflection, as if she can feel everything her replica feels. As if she understands and is understood for the first time.

X finds a hard drive labeled BIRTH:

Knows better than to plug it in.

X opens her computer and a window pops up:

She clicks REMIND ME LATER.

X sees her house:

She starts up the garden path, but is stopped by the words of some chesty, blooming peonies, real tough guys, "HEY! You can't go there. Stop!"

x: But this is my house.

PEONIES IN UNISON: You must wait to be invited in. The owner is particular about intimacy.

x: But this is MY house.

PEONIES: Have you heard of an "intimacy gradient"? You must learn to read the cues in the landscaping, in the architecture. We were planted here in such a way to let you know that you need an invitation to pass. When you are very good friends with the owner, she will invite you into her kitchen, this is how you will know you are quite close.

x: This is my house.

PEONIES: The Letter Carrier should have given you an invitation. Sorry, but without it we can't let you approach the door.

x: This is where I LIVE!

PEONIES: From some things you just have to run away. Home is sometimes one of those things, for better or worse.

X shuffles confusedly backwards and trips over something heavy and soft:

It is a big beige bag marked with the words DEAD LETTERS. She reaches inside and pulls out a letter with a big X on top of a smaller x. RETURN TO SENDER is stamped where the address should have been. "At least it's not SPAM! A bag of junk email would have to be bigger than New York City!"

X wanders into a soap startup:

They make soap called "Salp."

Their tagline is "Salp: Soap for your scalp."

X:

Salp is shampoo!

X turns herself into a letter (X):

Shows up at the Letter Carrier's door. "Mail me home! Return to sender!" X insists.
The Letter Carrier peers through tiny door. Only eyes show. "You're the wrong kind of letter. You could even be a number for all I know!"

He whispers, "Listen, a house is a coffin. A mind is a house stuffed with questions. Doors let one question out at a time, but keep the others inside. They escape in summer through open windows. Circles, cycles, wheels, right? Like a hammer or a feather in the water in warm weather.

Bury a seed to see if it grows:
The hole is a bed.
The hole is a coffin.

Whisper softer than the softest softness.

Listen:
This music turns rain drops upside down, refills the clouds with water and ships them off over the ocean to make room for the sun again."

X is very small and afraid.

X knows that anyone who is X tries to be X.

X prints out an image of Rihanna's pocket:

Folds it up, puts it in her pocket and only takes it out to whisper her secrets into it when no one is looking.

X can also tell she's in the '80s by the styles of popular flowers proliferating homes:

X becomes suddenly aware of a ridiculous atmosphere in a dead zone beneath a staircase in which had accumulated: fake flowers, old worn out Beanie Babies (they relaunched the brand as "Beanie BAEs"), some irrelevant floppy straw hats (it was winter), and too-brightly colored fabric scraps that were either too big to be cut up or too small to be used for picnics. Campy detritus loose in the pre-fab extraness of homes across America felt seen.

Outside on the lawn:

X sets an elaborate table. Its surface is sumptuously laid with her Nonna's lace. Cool salads soak in their dressings and warm dishes release steam into the atmosphere. Wine has been poured into crystal. Silver sets the table. She waits for no one. No one comes. She digs in. Tastes everything. Sits in every chair. Drinks from every cup.

X had experienced a stream of intolerable events as a child, sought solace in books which she read on a flat rock by a tiny creek at the bottom of a wooded hill behind the house. Now flat rocks feel homey, outdoors safer than rooms.

X unfolds the picture of Rihanna's pocket.

Discovers something written on the back:

Look at the statues disappearing into the distance. They have space to disappear. Rub your eyes to see them. It is a strategy where we miss what we hit.

X needs to be held, like anyone does. *My body must stop vibrating by the force of another's affection. I need opposite sine waves. I feel dispersed and want someone to gather me.*

X walks past a fabric shop window where shopkeepers are arranging a display of mannequins wearing hand-made clothes with fabric from the shop:

Overhears a female voice say, "Whenever ANY woman has a baby I take it very personally, like why didn't she consult ME first?"

X announces to herself:

"I am running away from being an eldest daughter. I will run until I was born second or third."

X meets a small canary:

And keeps it as a pet. She trains it to do all her email-ing with its beak from a special tiny keyboard mounted upside-down above the bathroom mirror while X gets ready for work.

The canary signs all the emails, "xx, X"

Unfortunately, the bird always hits REPLY ALL so one day X leaves the window open.

X walks back past the man in the hole who had called
out to her:

Look up! The patch of sky you see is your real home
I fell too, angel!
Landed in this weepy body
confusing myself and everyone around me with its
changing shape
It's fine! Be dirt, be mineral, be animal.

Name everything you want to save
you never know when you'll need it one day.
Might come in handy to have a scrap of some
"trash."

Here, I brought you this odd rubber band from
Bulgaria
for example
I'm using it to tie our wrists together as we
wander the halls of an enormous abandoned
skyscraper.
Uninhabited
built on the inflated numbers of a corporate account
imploded just like that and now we have a steel and
concrete
helium balloon as our play yard
the rent is so cheap it's free!

X decides:

Stories are becoming more discursive.
It's acceptable to ask questions of the text, from within
the text out to the world.

X asks:

What is the word of the city?
Everyone on the street is walking around thinking the
same thought.
If one's personal word doesn't match the word every-
one's thinking, then one doesn't really belong there.

X feels:

Her word is likely different than the others' and goes off
seeking those thinking the same word.
What word hovers over my head? Only someone who
can read will tell me.

X texts Mom:

> What does it feel like to b alive during apocalypse?
> Are there cobblers and tailors anymore?
> What do they think about while they mend?
> Is the dying art of mending how we can tell it's apocalypse NOW?
> Like—what's the point?
> Or do mending and caretaking become cool bc of inherent absurdity?
> And who mailed that letter?
> Who lives in my house if not ME?

X throws words around at random to see what sticks. Says so many stupid things.

X takes out her phone and shoots video.

X submits a request to the air, "Put me and everything I see in a movie about someone else's life. Make THEM the main character. I want to be atmosphere."

The atmosphere is more powerful than the main character anyway. Movies are about power and control the way sex is about power and control. We navigate movies like we navigate the city. We pray the shape of our journey is dictated by a benevolent architect. The more evil the architect, the more resistance we face and the more discipline we must have.

In the city, back on the street, X passes a window with a song floating out like a wide ribbon of pappardelle pasta which X devours hungrily. The woman's voice is so beautiful and vast that it nourishes her and makes all the hairs on her spine stand straight up, suddenly awake, organized, ready to march.

X hears the woman sing:

Discipline isn't about winning a fight.
It's about diverting your attention.
No matter the effort.
To love.
To love.
To love.
Always to love.

X passes another store:

Where everything is on sale, even the fixtures and man- nequins. The naked mannequins are arranged by size in the window facing the street. The child-sized ones have "Please take me! $50 :-|" and "Take me home with you!" written on their chests. The adults are $45 but are just from the hips down: no head, no torso. X examines their hands, which have been bent and contorted to make pain- ful looking gestures, as if trying to communicate, or beg for help, in a language she can't translate. Their faces are featureless. A smooth globe where the genitalia would be.

On Valentine's Day X and her boyfriend skip out holding hands and shoplifting. Walmart is their favorite target because they fund anti-abortion activities.

On Valentine's day morning they text:

> x: What should we do today to celebrate our love?
> BF: Steal from Walm?
> x: But we just did that last week\nd :-?
> BF: So fun tho!!!1
> x: K but let's steal something big this time. Ppool?
> BF: Gr8 I just put a hitch on my truck so we can just hook whatever to it

X puts an orange PAID sticker on the pool, hitches it to the pickup and they fill it with:

25 red hoodies
9 pairs of gardening gloves
5 BPA-free water bottles
USB cords (handful)
Gardening hose
Garden statues
iPhone cases
Stereo system
A shopping cart
4 picture frames
An acoustic guitar
A synthesizer
Drum kit
Kitchen table and chairs

Wireless keyboard
Kenmore washer/dryer combo
Mini desk calendar
Wall clock (for the kitchen)

On the drive home, X thinks, "All the best work is a love letter. Maybe some is hate mail."

In the truck's cab, X tells a story too complicated for pictures. It's just a smell.

X comes to terms with being a mediocre storyteller:

There are too many words.

X resolves, "It's OK, I'll grow into it."

X gets a gift card in the mail:
Good for $25 at Walmart. It comes inside a Hallmark card. On the front, an image of a framed photograph of orange lilies on top of which is a scrap of yellow Post-it:

"ONCE YOU BECOME A *MOTHER* YOU STOP BECOMING THE PICTURE AND START BECOMING THE FRAME."

X considers:

In a cellular sense "we" is a frame.

X travels by air to Harvard:

Buys enough Harvard sweatshirts for everyone in the entire world to wear at once. A maroon sea waves to her as she waves down from the window seat.

X collects trash:

At night she sneaks into the richest neighborhoods, ornamenting the lawns with a mini portrait of each house in local detritus. A 1990s stone cottage, made to look like something from a British seaside town, reconstructed to scale with empty cans of Spam and sardines, alternating, for the stones. Crumpled Chinese ginger candy wrappers convey the flower garden.

X sleeps all day and now it's dark:

Time to go out to the club. Dancing, drinks. Finally feeling like herself, X increases to 5 times her size.

X tires of being "the Big Woman," crowds of sweaty bodies around her, grinding, absorbing her round soft curves:

As if in a trance, a young man in a lime green sequin g-string worn outside his pants rhythmically caresses her ankle with his palm, three girls in matching irides-cent pastel camisole dresses hold hands in a ring around her undulating thighs, two butch goths jump up and down behind her with their arms in the air laughing and "high-fiving" her ass over and over. X is "touched out." Time to spend too long in a bathroom stall.

Facing the bathroom mirror X is finally alone:

What is that sound? Above the muffled bass from the dance floor, a barely audible high-pitched sound, com-ing from outside in the parking lot.

X chooses:

A white Sedan with a bell attached to its side view mirror. The bell rings whenever the car moves, no honking, just a general tinkling sound towards the world.

X slides:

Beneath the car and holds on. She goes wherever it takes her, hoping it's the beach. It's surprisingly easy to travel this way if you are unattached to your destination.

White knuckling it on the hot, vibrating metal chassis, X suddenly remembers:

The nurses in the hospital coming in at all hours of the day and night, regardless of whether she was resting. As she was checking out she looked over her shoulder, noticed a sign that read: "Please do not disturb! A new mother is recovering!" which could have been placed on her door.

X remembers:

In the hospital, after everything went wrong that could have gone wrong, saying to the anesthesiologist, "Just fuck my shit up," which he did with Dilaudid.

X saw double and it was the first time anything went right. Fuck her up was the one thing he knew how to do. Evacuate sensation. Replace it with its hollow, offset twin. Echo feeling.

X reads headlines and imagines being everyone:

The Speaker of the House, the President, the victims of unjust policies, the ravaged environment, the twin vale-dictorians, the baby pet leopard that was found hidden in someone's basement, the man who was keeping the leopard there, the traffic cop who got hit by a snow-plow, the snowplow, the snow, the air, the sky.

X backs up her hard drive:

To another hard drive and takes that hard drive, copies it, and places both in different plastic containers, seals them completely, then uses a garden hose to submerge her whole house under water.

X waits 17 years:

Dives underwater to investigate her archives.
The cloudy plastic is coated in barnacles and mussels that come loose easily. They are delicious with fries.

X has lost touch with many of her friends, but DMs Mushroom to see if she's around:

> x: You around? I'm here.
> MUSHROOM: …
> x: …?
> MUSHROOM: OOOOOOOOOOOOOOOOO OOOOOOOOOOOOOOOOOOOOO
> x:?
> MUSHROOM: SOrry, KeYbOArd BrOken lEts HA Ng?
> x: Let's meet at Walm?
> MUSH: 👍 I'll B in hunting SECtiOn AssEssing CAmO

X starts a social media profile:

An empath on the internet is a tired reader.

X feels exhausted from imagining being everyone:

Lies down in her bed and wakes 10 years later, still tired, but with longer hair. The thought of cutting it exhausts her. She goes back to sleep.

X sets limits in her phone to control her use:

PHONE: Ignore limit?
x: Yeah

PHONE: Ignore limit?
x: Yeah

PHONE: Ignore limit?
x: Yeah

PHONE: Ignore limit?
x: Yeah

PHONE: Ignore limit?
x: Yes, but this time only for a minute or two.

PHONE: People think technology is a tool like a hammer, but it's actually a part of your unconscious externalized.

x: Once it's external then we can see it better.

x: Exactly.

x: If we can see it we can…

Kuleshov Effect

Person looking at phone
Crying baby
Person looking at phone
Sexual encounter in a car
Person looking at phone
Slowly cutting a big white fluffy cake
Person looking at phone
Clock turning noon
Person looking at phone
Video game death
Person looking at phone
An orange leaf falls slowly
Person looking at phone
A blaring fire truck drives at top speed into the side of a
docked cruise ship
Person looking at phone
Bombs dropping on a Syrian mountainside village
Person looking at phone
A carpenter finishes sanding a bench
Person looking at phone
A school of tropical fish swim from left to right in front
of a coral reef
Person looking at phone
Video monitor displays how to massage a foot in the
window of a shop in Chinatown
Person looking at phone
White people picnicking in an urban park in America,
a Frisbee flies over a spilt bottle of rosé
Person looking at phone

X boycotts Walmart:

She makes signs that say "STOP STEALING FROM WALMART" and marches in a circle outside chanting "FUCK WALMART!" Confuses and alienates everyone. Feels good to make some declarative statements. She waves to the camera and pumps a fist into the air. Huge grin.

X remembers her body:

Looks down at her open palms, and as in the movies, they tell her she's changed. The hands of a baby gaze up at her. They clench and unclench the air, just for the pleasure of movement, of witnessing one's nascent agency.

X takes a 23andMe test because her insurance offered a limited time rebate if you made your data accessible to them. People wondered, "What do I have to lose?" X knew she had a lot to lose, and did it anyway. All her greatest gains have come from losses. Also, there was a 20% off sale for Father's Day.

X discovers some facts about her biological father:
He enjoyed cheese but couldn't tolerate it well
He was sensitive to coffee
He *likely* wore rope sandals in the early '00s (inconclusive, need more data)
Was gay????
Drew the alphabet over and over in different curly fonts for fun while he graded papers
Mediocre gardener
Mediocre winemaker (though enthusiastic!)
As a child he tried to ride a bike, crashed it in a back alley, never learned
Soft hands
Inquisitive mind
Kind smile
Hiked in the woods and ate every mushroom he found (which led to his early death)

Launched into confusion about her ancestry, X decides she needs a makeover:

She Photoshops her face onto Y's body then decides Z has more dramatic brows so swaps those out, then puts H's hands on, with K's soft, smooth elbows, then the knees of P, the bony fragile ankles of U, the delicate clavicle of W, the shocking white hair of D's mom, (X has always loved shocking white hair played against a still young face), the regal head shape of G, the upright posture of F's spine, the long spider legs of S, the direct stare of R, the beauty marks of L, the plump upper lip of O, and the cute ears of N. Satisfied, she prints the image out, folds it into a paper plane and throws it off a steep cliff. Watches it float down into a canyon, taking the air like a happy child bounding down the steps at the end of a school day.

X feels chaotic and decides she should reorganize:

Takes her extension cords, VGA adapters, FireWire Cables, USB 1, 2, and 3 cords, HDMI cords, RCA cords, various dongles, Lightning Bolt adapters, charging cubes, bundles them up and climbs a tall ladder to the top of the house. She drops them into the chimney, still full of water, so they bob at the top like a messy buoy.

X flies a kite:

Ties a string eleven miles long to a California Condor feather, which is 6 feet long and a foot and a half wide, brings it to the airport, and jogs along the runway beside planes during takeoff.

X falls down an internet rabbit hole:

Watching YouTube videos of luggage riding on airport conveyor belts. Watching the luggage go around and around she identifies so completely that it was as if she herself was a piece of luggage waiting to be claimed. She goes to the airport and films some pink luggage lying on its side as it emerges through the dirty rubber flaps of the square hole in the wall. Its pinkness makes her think of a newborn being conveyed into the world in the calmest way imaginable. This thought horrifies her. *Stillborn*, she shudders.

X gets spam from 23andMe:

See your new reports! You have a new trait report available: Fear of Public Speaking

X, curious about how people structure their time, asks Mushroom about her morning routine:

> MUSH: I'm up and dressed by 5:30am and I go outside and look at the grounds. Does the pool need cleaning? What's the condition of the sea? And I always listen to Morning Joe. I don't watch it. I listen on my iPhone with TuneIn Premium so I don't have to hear commercials. My baby's always like, "Why don't you just turn on the damn TV?" But there's something I like about just hearing voices. I'm not distracted by the funny look that Mika may give Joe, or what they're wearing, any of that.
> X: And when you're outside, how do you listen?
> MUSH: After laughing, music is the most important thing in my life. When I'm on the subway or on the street or at the gym, earbuds block everything, so you don't have to hear people's ridiculous conversations.

X thinking to herself, "But I LIKE people's ridiculous conversations!"

X gets more spam from 23andMe:

See your new reports! You have a new trait report available: One Long Chin Hair

X writes a list of all the things that make her happy:

The only thing she can think of is loitering. She decides to loiter someplace different every day from 2 to 3pm. She starts somewhere easy—outside a 7-Eleven. She tries to loiter at a bus stop, but tires of not taking the bus and eventually just gets on. She tries to loiter at the airport, but security suspiciously turns her away. She loiters in an empty parking lot, standing in the shade of a tree, quietly thinking of other places to go. At home she loiters in front of a mirror, avoiding her own gaze. She picks up her heavy, floppy mattress, heaves it against a wall, and stands around in the empty bed frame. At the beach she loiters beneath the ladder of the lifeguard seat. At the movies she loiters on the other side of the screen, casting a vague shadow on the narrative. She loiters at a shopping mall, riding the escalator up to the fourth floor, down to the basement then back up and down. She loiters in the bathroom at Chipotle. She works her way up to the museum, where no one can tell the difference between looking at art and loitering, until she hangs out in a doorway between galleries. The security guard finally asks her to please proceed into the next room.

X wants to plug in her phone:

She climbs a tall ladder up to the roof to get a cable from the chimney. But this time there's another house, exactly like hers, built directly on top. She climbs to the roof of that house and extracts a USB cord from the buoy in the chimney.

X checks her voicemail:

> A FEMALE VOICE: Hey (*garbled sounds*) grab (*unintelligible*) grass groundesslingggggg grrgrrackk go. OK bye!
> VOICEMAIL: You can replay the message by pressing one.

She presses Mushroom's red and white cap firmly.

> MUSHROOM: Hey!
> X: I would like to hear the message, please.
> MUSHROOM: *Suddenly there's a cool Carol King vibe, slow piano chords playing in the distance.* Look, if I could go back in time to when I was just a young girl and the whole world was wrapped around me like a warm blanket, when no good thing could be taken away, when it was all the same cozy material, me and everything all mushed together and soft, I would, but that's not how time works. You're gonna be just fine. You were born in a century where memory gets easily lost, rearranged, where friends and family exist outside of physical proximity more often than not. Our hearts are tethered to theirs by invisible threads, fortified by frictionless electric gestures over virtual power lines. But the feeling of connection is real even when the heat from their palm is not there. Touch matters more than ever and it's the hardest thing to find. Contact. Massage appointments are impossible to make in the age of social media. So many mani-pedis. People want to feel real, remind each other of their corporeality.

Hear heartbeats. Sync biorhythms. Some unfortunate souls even self-inflict injury and conjure illness for that sweet moment of the stethoscope on their chest, the warm body of the doctor bent tenderly over, listening, breathing, looking up bright-eyed and reporting with calm authority, "Everything sounds good!"

X goes to the movies with Mushroom:

MUSHROOM: I like to watch people smoking in the movies so I can see the shape of their

Breath rises in her exhaled smoke, commingles with the smoke on-screen.

X in the city:

People are breaking up on every street corner. Must be the season. Tulips are blooming, relationships are ending. Someone stands alone sniffling on the phone, "No, it's good, it's good. I mean, we both really care about each other, so that's good. And on the bright side…"

X gets more spam from 23andMe:

See your new reports! You have a new trait report available: Ability to Match Musical Pitch

X shops online intuitively as if in a trance:

Experiments with reading her virtual cart like a tarot. Tells her what she's lacking, what she desires, what she perceives as outside of herself. Each cart is a self-portrait in products. Each one tells a story about her unconscious.

X goes back to the hole from which she was catcalled:

The man is gone, the hole is empty. She takes all the cables and USB cords that she had bundled up, straightens them out, ties their ends together, and one by one lowers the long line down into the hole. The dark hole is a period into which the sentence travels.

X's fatigue also comes from:

Living amidst a generalized atmosphere of hostility due to:

Constant threat of violence due to:

Guns and other weapons
Having a female body
Expressing sexual desire
Experiencing the sexual desire of others
Having certain religious beliefs
Having other beliefs
Living in a certain place
Appearing to belong to a race
Illness
Money
Massively catastrophic changes in weather patterns
Not eating enough Italian food ("You don't EAT!"
chastises Nonna)

X remembers being young and feeling "different":

Raised in a family of various unrelated objects whom she was taught to consider siblings. At the time the leap made her uncomfortably aware of her family's difference from the other families she knew. Dad smiled, proudly holding up a spatula, "Say 'Welcome home' to your new brother!'"

Having to answer the cruel question of schoolchildren over and over: "Is your brother ADOPTED? Since your brother is adopted it means he can be your boyfriend! Ew! Ha ha ha!"

But she now realizes this learned ability to find common ground with anything, or anyone, is a strength, not a weakness.

She turns, smiling, to Mushroom, "Hey, sis."

X's stomach is sore which reminds her that she did some moves and gestures yesterday that she hadn't done in a while. Now that her body has "awoken," she realizes she's been asleep from the bottom of her ribs down to her feet. Her flesh was all on autopilot, for who knows how long. That's what trauma does. Stops time without announcing it.

> x: It's amazing how my cells know what to do without me.
> MUSHROOM: The nature of trauma is that you can't remember it as a story. Your brain doesn't allow a narrative to cohere. The traumatic experience remains discrete, amputated from its context. Trauma is an image.

Now X feels the "problems" where her stomach forgets how to hold itself, relies on her back for support, and the arches of her feet have collapsed from the exhaustion of carrying the weight of another body in addition to her own. She greets these aches happily! Welcome home! Back to this floppy body with the pains telling a story of what happened and what will certainly change. Pain is the voice of what can heal.

There is the ache that is here now and the aching memory of the ache that isn't really here. X listens to both.

It's getting late and dark. Soon there will be light again. X remembers that rhythm, if nothing else.

It's been a long day, or season, or lifetime. How do we count these moments that cascade unceasingly in language?

X makes videos in order to remember gestures in time, the matter and mass she was capable of shifting. Traces of her will. Evidence of her force and her witness. That will change, she is certain, as her body ages, her mind ages, and the world's recording devices evolve and "advance." She persists in making videos in spite of their ephemerality and because of that same quality. Video is fragile, contingent on mechanisms beyond itself and difficult to maintain over lengths of time. It's a good enough medium in which to express the ordeal of having a body.

X wants evidence of thoughts and decisions, bread-crumbs on the forest floor. She needs much more than a single photograph. X wants a context. She wants a pattern, a choreography of her mind's flawed attempts to create cohesion, to see both the dots and the spaces in between.

X is standing in the Atlantic Ocean off the coast of New Jersey:

The cool, calm water hugs her waist. Nobody is around, not even a gull. She surveys the clear horizon. Humming to herself, she holds her palms just above the surface so she can feel the lapping water, a lover's kiss, happy she's returned. She closes her eyes and feels the warmth of the sun on her face. Maybe she's home?

She opens her eyes. A $20 bill floats a few inches from her open hand. She grabs it and starts to swim back to the shore.

SENTENCES ON

Frames
Screens
Ladders
Doorways
Mirrors
Bathrooms
Bus stops
Waiting rooms
Airports
Shopping malls
Parking lots

FRAMES

Fall asleep and dream on one, the witness of passion and unconsciousness.

Name aka turn nothing into something.

A system—make a sound a word.

Circumscribe a concept.

Are defined by the shape and size of the concept.

A person's job frames their efforts and activities.

Italian + English: *Fra*/Between + *Me*/Myself = "*Fra me*" or "Between Myself."

Is the frame me? Is my body a frame?

Is my body too "loud," distracting from my soul?

Is my body the wrong shape for the idea of "me"?

SCREENS

Skin: a necessary obstacle.

Delineate a plane in space.

Activities are allowed on one side of the screen that would not be allowed on the other, i.e. being completely naked.

Project upon their surfaces literally, as in a cinema, or figuratively, as in someone waiting for someone else to change their clothes behind one and imagining their naked body.

Peer through, walk around, bounce off of or peek over/under one.

Knock it over, a screen falls flat, taking its time on the way down as it catches wind like a sail, full of breath, expiring a slow sigh.

A standing screen makes one person a creep.

A movie screen makes everyone a creep.

Silent witness, listless listener.

Full of holes, a screen sieves reality through fantasy.

LADDERS

Invented 10,000 years ago to reach honey.

People (short) love honey (high).

Parallel lines collaborate with horizontal lines to create the spine.

Some are attractive furniture while others are portable architecture.

Fallen ladder awkward bridge.

Delineate a vertical path between horizontal planes.

"Jacob's Ladder" symbolizes fluid communication between the dirty earth and sublime heavens.

An escalator is a capitalist Jacob's Ladder, effortlessly moving goods and people back and forth from one floor of a shopping center to another.

"La" + "dder" is a song and a stutter-fall.

Do Re Mi Fa So La Ti Do.

DOORWAYS

The space between other spaces, such as room to room, room to hallway, or interior to exterior.

Punctuates your penetration into more intimate social corners.

Joins pairs: past and future, good and evil, joy and sadness.

Loiter in a doorway. Keep options open.

A knock at the door—ominous and foreboding. A door slamming—anger, rejection.

Brief space between breaths to finish one thing and anticipate another.

The right attitude "opens doors." Did cave people care about their attitude? Did caves have doors?

Video transitions (fade, wipe, etc.) extend the experience of being on the verge, of not quite knowing yet, of being about-to-know, about-to-see or hear, about to experience a new moment, or of simultaneously entertaining two different ideas at once.

Coming to or leaving consciousness (waking/sleeping).

Pussy: doorway to a womb—welcome home!

MIRRORS

In their cool eye, unblinking and without judgement, an image of the judge.

Show the liar and thief the real liar and thief.

Will reflect the camera and photographer, resist photographic reproduction.

The more expertly a mirror is photographed the more it looks like nothing but a grayish geometric shape.

Serve their function best when it is noticed the least.

Frame yourself in the surface of the mirror with photographs tucked into the sides, your imaginary audience.

Cinematic tricks employ reflections in shot compositions to confuse the audience's perspective, collapse space or to tell us something about a reflected character's interior life.

Wrap a mirror in plastic, preserve it. Turn it around, throw a rug over it. It sees the rug, the throwing, the turning around.

A mirrorball shines over the dance floor, ecstatic light shoots out, tiny dancing beams. One's inner moons. One's outer self turned small and multiplied sprays all over the room.

A lover is not ever a mirror, but every lover loves a mirror. Ecru looks lovely on everyone.

How is it that we age by looking? Do looks age? If we never looked would we never age?

BATHROOMS

A bathroom with a door that doesn't lock is so stressful. "She's been in there FOREVER. What's she DOING in there?"

The only private room in a small apartment. A phone booth. Connection/isolation.

Shower to transition between two states, defined by nakedness and wetness.

Stand up at the dinner party to go to the bathroom for a moment alone.

She went into another world: transported through a mirror portal into a pore. While cleaning pores she forgot about death.

Time slows down in this sensory place. The threshold extends and reality slips away as we zoom into an errant hair while looking in the mirror, or start singing in the shower.

Living involves much maintenance which takes place in the many bathrooms of the world.

For a good time call X. Bathroom stall scratched confessional. "Come out" in one.

Hear your voice. You sound amazing when you sing in the bath. Your day washes off into the music, thickening steamy tones, wet notes.

WAITING ROOMS

Time requires form and will take the shape of its
container.

Not enough seats for comfortable distance. A person is
forced to feel another's hot sleeve.

Gazes avert avoiding conversation.

Movie theater: where our feelings are more real than
real life, where we spend time before we can go out
into the sun again and feel things and do things in an
ordinary way.

A womb: the first waiting room.

Soft songs take the edge off. Soft voices coming from a
specific place, the boombox on the corner table.

Depending on your relationship to resisting the circum-
stances of your life, the whole world can be a kind of
waiting room between birth and death.

Tell me jokes until they call my name.

Piles of previously pawed magazines sticky with film
of perusal and passing time mindlessly, a haptic metro-
nome, flimsy pages turn.

Spilled takeout cup: "That's fine, I'll get it." Too many
paper towels, balled up, blot at the feet of strangers.

Architecture as stage for capacity and volume. People
filling and emptying the chairs. Sand filling and empty-
ing the glass.

BUS STOPS

Hell: standing desperately in the middle of the empty street looking for the bus.

Heaven: the view from a bus window.

The sign that tells you you are at a bus stop suggests a general area and often people mill around, waiting as far from the sign as they can—even inside nearby delis, coffee shops, wine stores, etc. Anywhere within view of the stop.

Turns the outside into a waiting room, a command, a recipe, a prescription, and a suggestion.

More intimate and abstract choreography than a subway stop.

One who waits is oxygen and the bus is the lungs of the city breathing people in and out.

One can judge how soon the bus will arrive by the number of people waiting for the bus. The more people are waiting the sooner it will arrive.

Each bus has a name, a letter, and a number, which we call the container that will carry our bodies.

What makes the face interesting is the skull inside it. What makes the bus interesting is the people inside it. Their desire to move creates experience and changes the mood of the bus.

AIRPORTS

Where time is prismatic and folds like origami.
They say there's always one small thing one can do to become slightly more comfortable while traveling, like chewing gum.
Thick white noise, an ominous calm, a sticky blue cotton candy blanket dulls metallic clangs and luggage bumps, dampens a shrill stressed-out voice.
Space is permeable and shoes come off in public like it's normal.
Cables running out of charging station like an IV drip ever refreshing the data stream.
A bearded man in large brown leather jacket plays the vibraphone in a wide hallway between gates F and G. The vibrations cause rare calm and unexpected plea-sure, even for those not listening.
Locus of both connection and disconnection, as if in order to connect in one way we must disconnect in another.
Even just the idea of an impending thunderstorm in NYC has created total chaos in Toronto. Weather hap-pens each time like the first time it's ever happened.
Drinking any time day or night. Groggy zombies wan-der on relaxants still en route, staving off alertness. 24/7 PJ party. People need numbing.

SHOPPING MALLS

Sprawling conglomerate of enormous cubes.

A run-on sentence of buildings. An amoeba of commerce and anti-commerce.

Products fill stores fill geometric space. A retail Rubik's Cube of narrative possibility.

No real reason one store is next to another. Rented associations.

Readymade narratives for sale.

Shoplifting is popular. Tempts everyone who goes into a shopping mall. Stealing is a right of passage.

Crossing the threshold from what to what? Not having the thing to having it? The realization that unsatisfied desire comprises living itself? That the satisfaction of all desires is a kind of death?

Lose yourself in shopping, lose yourself in the search for the new you to lose.

Depressing fluorescently lit warren with upkept HVAC. Cheery bunker.

Walk right in like you own the place, like you've been there before. Walk past Hair Today Gone Tomorrow, past Waggy Tails Doggy Daycare, past the Orange Julius kiosk, past The Gap, past Spencer's Gifts, past Pinkberry, past Wilson's Leather, past Express, past Panda Express, past The Limited, past The Limited Too, past Nordstrom, past Target, past Ruby Tuesday, past Best Buy, past Bed Bath & Beyond.

PARKING LOTS

Smoking weed in a car in one.
Doing it doggie style in a car in one. A dog watches from the driver's seat of the next car.
Sell your car in one.
A relief from cars, full of cars. Your car dies in one and it's a blessing and a curse.
Park and just walk away.
Park close if you're lazy, sick, pregnant, or tired.
Park far if you're a sneak, freak, or want exercise.
Pave a new parking lot: Congrats! You're "The Man."
A crowded parking lot: the ultimate clusterfuck.
Desire: empty parking lot full of so many letters but not a single word.

INDEX

A

B

C

M

N

O

W

1,2,3

SOME REFERENCES AMONG MANY OTHERS

Blaise Cendrars, *Moravagine*, trans. Alan Brown
(New York: New York Review Books, 2004)..pp17–18

An Unmarried Woman, dir. Paul Mazursky, 1978...p25

Giorgio Agamben, *The Adventure*, trans. Lorenzo Chiesa
(Cambridge, MA: MIT Press, 2018)...p29

Flann O'Brien, *The Third Policeman*
(McLean, IL: Dalkey Archive Press, 1999), 49..p49

Christopher Alexander, Sara Ishikawa, and Murray Silverstein,
A Pattern Language: Towns, Buildings, Construction
(New York: Oxford University Press, 1977)..p75

Jack Spicer, "A Piece of Marble," in *My Vocabulary Did This to Me: The
Collected Poems of Jack Spicer*, eds. Peter Gizzi and Kevin Killian
(Middletown, CT: Wesleyan University Press, 2008)..........................p85

Weyes Blood, "A Lot's Gonna Change," in *Titanic Rising*
(Sub Pop Records, 2019)...p116

ACKNOWLEDGMENTS

A car's catalytic converter contains platinum, turning toxic carbon monoxide into carbon dioxide, an essential component of our respiration. Rachel Valinsky, without whose energy, trust, generosity, vision, and insight this book would not exist, is a platinum catalyst. I breathe easier because my work is in her hands.

We never really do anything alone, even when we think so. I hope my gratitude illuminates the relationships that made this work possible. With the help of Wendy's Subway, I have made an effort to index the specific references to the work of other artists which appear within these pages, though I am sure I have forgotten many influences and many more have acted upon me without my awareness.

We work together and live together, despite inhabiting systems which aim to divide us. In rare cases I admire virtuosity, but more often I respect energy and spirit. I am truly grateful to be making art in this exact moment, however one wants to characterize our time. Thanks to all the artists who sublimate the often painful contradictions in their lives into understanding, humor, and unusual beauty.

Thank you: Corinne Butta, Harris Bauer, and everyone at Wendy's Subway for their care, attention to detail, and insightful questions. This book owes its shape to you. Joseph Logan, my dear and talented friend, for going on a typographic adventure with me once again, as well as Brian Hochberger, and everyone at the studio

for bringing the book's physical body into being.
Lumi Tan, Margot Norton, Nicole Russo, Vic Brooks,
and Abina Manning, who have given me their time,
trust, energy, and encouragement. Juliana Romano
for always being ready to find yet more ways to share
love and delight. Martine Syms for the steady friend-
ship and inspiration. Jana Blankenship for showing me
what it means to expand. Julien Raffinot for exuberant
feeling, prismatic thinking, and oblique views. Nick
Younes for sharing exquisite words. Brianna Antonazzo
for your positivity and readiness. Carol Bove for the
many invitations to question form and structure over
the years. Corrine Fitzpatrick for observing in such
precise, inquisitive, poetic, and generous ways. Wayne
Koestenbaum for writing "In Defense of Nuance,"
in particular, in addition to so much inspiring work.
Joseph Williams for collaborating with me to create the
music for *Like Clockwork* and Kristan Kennedy for the
initial invitation to perform it at the Portland Institute
for Contemporary Art. Fred Magenheimer for won-
dering out loud. Geri Magenheimer for transcribing
my first stories. Michael Bellsmith for an incalculable
spectrum of love and support. Nuno Bellsmith for
unzipping me to reveal another me, spending this first
year teaching me how to mother, and redefining that
word amongst many others.

This book is dedicated to:
Nonna Bridget and her many languages.
Michael and Nuno, my home.

BEIGE PURSUIT
© 2019 Sara Magenheimer

Image credits:
Cover and page 69: *Architectural Digest*, January 1982
Pages 70-71, and 83: *Architectural Digest*, September 1982
Page 72: *Architectural Digest*, June 1982
Page 82: *Architectural Digest*, October 1982

Document Series #2
First Edition, 2019
Edition of 500 copies
ISBN: 978-1-7327086-3-1
Library of Congress Control Number: 2019945896

Edited by Rachel Valinsky
Editorial Assistance by Harris Bauer and Corinne Butta
Proofreading by Corinne Butta
Designed by Joseph Logan and Brian Hochberger
Typeset in Bembo and MCKLSH
Printed at McNaughton & Gunn, Michigan

Distributed by SPD / Small Press Distribution
www.spdbooks.org

Published by Wendy's Subway
379 Bushwick Avenue
Brooklyn, NY 11206
wendyssubway.com

Wendy's Subway is a non-profit reading room, writing space, and independent publisher located in Brooklyn.

The Document Series is an interdisciplinary publishing initiative that highlights work by time-based artists in printed form.